GODDESSES

to Eric & Nina

much strength
ad
energy for you

Mayu Oda

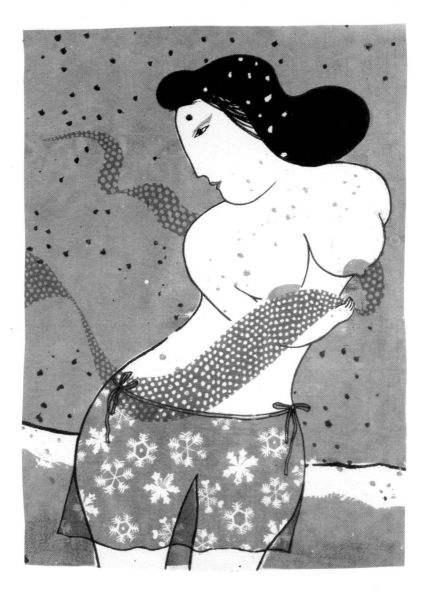

GODDESSES *Mayumi Oda*

VOLCANO PRESS / KAZAN BOOKS　　Volcano, California

GODDESSES by Mayumi Oda

Copyright © 1981, 1988 by Mayumi Oda
First published 1981 by Lancaster-Miller Publishers
Expanded edition 1988, Volcano Press
First Printing September 1988
Second Printing September 1989

Volcano Press, Inc.

P.O. Box 270
Volcano, California 95689
(209) 296-3445
Telex: 650-3491755
FAX: 209 296 4515

Typography by CaliCo Graphics
Printing by the Dai Nippon Printing Co., Ltd., Hong Kong
Design by Marie Carluccio Design

Production by David Charlsen & Others

Title Page:
Goddess in Snow
(22" x 29") 1983 ed.35

Jacket:
Rainbow Goddess
(23" x 31") 1976 ed. 75

Library of Congress Cataloging in Publication Data

Oda, Mayumi, 1941-
 Goddesses.

 1. Oda, Mayumi, 1941- . 2. Goddesses in art. 3. Buddhism and
art. I. Title.
NE2238.5.026A4 1988 769.92'4 88-190
Rev.

This book is for my two grandmothers
 Ai Oda
 Hisayo Oda

and my mother
 Aya Oda

GODDESSES

I can see myself when I was five years old, sitting on the *tatami* floor of our dining room. On the round, low table is a new set of crayons my mother has just bought for me, a precious gift in those difficult days just after the War. The sliding paper doors to the garden stand open; the crayons are bathed in light. The colors, spreading before me like an intense rainbow, beckon me. I begin to draw a princess: golden-yellow hair, a pink bow, tiny red shoes. I surround the princess with red and orange flowers and fill the sky with purple butterflies . . .

I have never stopped drawing, and color continues to cast a spell on me. I love crayons, colored pencils, watercolors,

Manjusuri

Manjusuri is the perfect wisdom Bodhisattva, usually depicted with a sword. This feminine Manjusuri carries a sutra as a symbol of clarity.

In Japanese Buddhist tradition Manjusuri was depicted as a young, smart boy who was just a bit arrogant. He is one of my favorite deities because of his youthfulness and sharp tongue. I often wondered what it would be like if he were she. In our tradition, there are so few female images of deities. It is up to us to create our own. I borrowed the flamboyant style of the turn-of-the-century bicycle poster. I think people at that time treated the bicycle as a symbol of the wheel of liberation.

(29" x 40") 1980 ed. 50

and I love blank white paper, a space where I can make my dreams come true.

When I recall my past, it reveals itself to me in two different forms: as an infinite number of distinct moments like seeds, and as a vast emptiness. Sometimes I can take these seeds in hand and examine them separately; other times they merge indistinguishably into an endless flow, a river of memories which empties into an even vaster sea.

I was born on June 2, 1941—the year of Pearl Harbor—in a suburb of Tokyo called Kyodo. My father, Yasumasa, twenty-nine, had just completed his graduate studies in Buddhist history and was teaching history at the Imperial

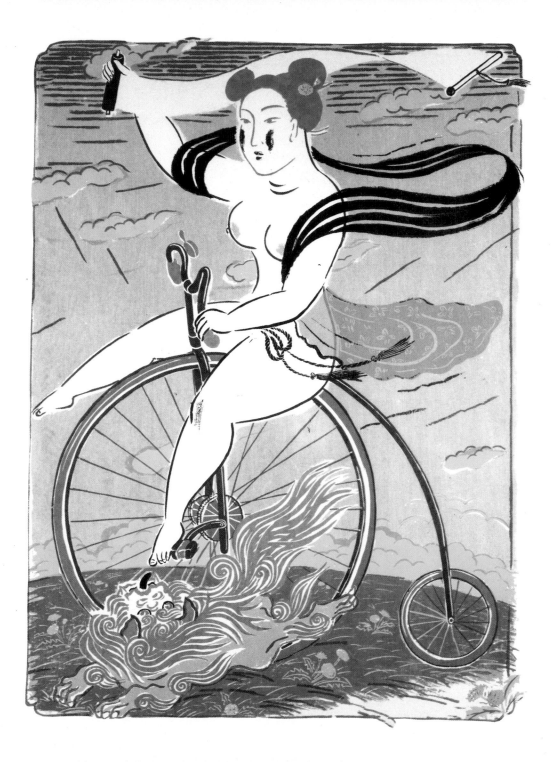

4

Thunder Goddess

The Thunder God was an evil demon in the sky. When angry, he would hurl lightning bolts, and then descend upon the house and eat the belly buttons out of children. Whenever we saw lightning we would rush under the mosquito netting with my grandmother, terrified; and grandmother would repeat this mantra with all her might: *Nam myo horenge-kyo.*

(22" x 29") 1970 ed. 50

Army Academy. My mother was twenty-six, the youngest of seven daughters in a cultured and artistic family from "downtown" Tokyo. She married my father one year previously—an "arranged marriage"—and went to live with him and his parents in their Kyodo house. My mother was a tall, ample woman with unusually fair skin; she was often likened to the Kannon Goddess.

The house where I was born and grew up is a typical middle-class Tokyo house in traditional Japanese style. My grandfather had purchased it with his retirement allowance; at the time, it stood alongside an identical house in the middle of a wheat field. That field has long since disappeared,

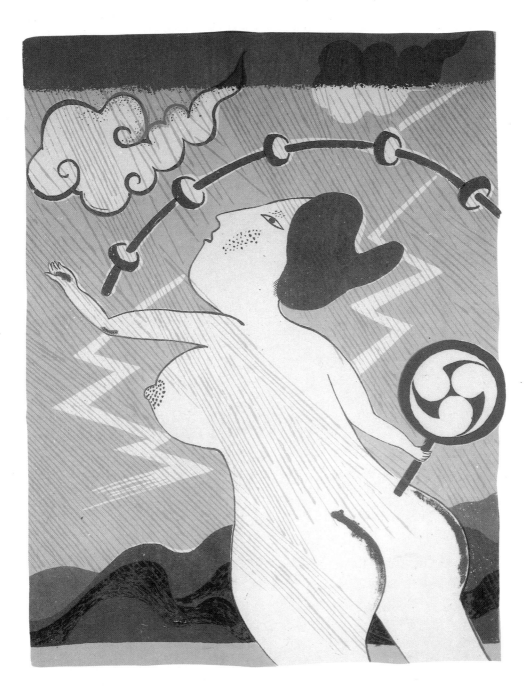

Sea Goddess

Kanoko Okamoto, the novelist, was born on the banks of the Tama River late in the 19th Century. In her novel *The Wheel of Life,* a woman named Choko (child of butterfly) abandoned her home and her lover and became a beggar drifting down the river, until finally she is swept into a vast sea called Life. For Kanoko Okamoto, both the river and the sea represented the vast power of womanhood. She wrote:

> The river is bountiful, as though nourished by an inexhaustible breast;
>
> The river empties into a vast sea enfolding everything, never ending.

(22" x 29") 1973 ed. 35

but the house itself is unchanged. When I visit my brother and his family, who live in the house today, I become five years old again. Playing shadow games with my two nieces, I cast my shadow on the same white paper in the same sliding doors, smell the same earth in the garden where we sit playing on the same straw mat, watch the same afternoon light filter through the trees—nothing is changed, as if time has stopped.

The land on which our house stood belonged to the Matsubaras, a farm family who lived across the way. As I grew up, the seasons of the year were marked by the sights and sounds which reached us from the garden in front of their

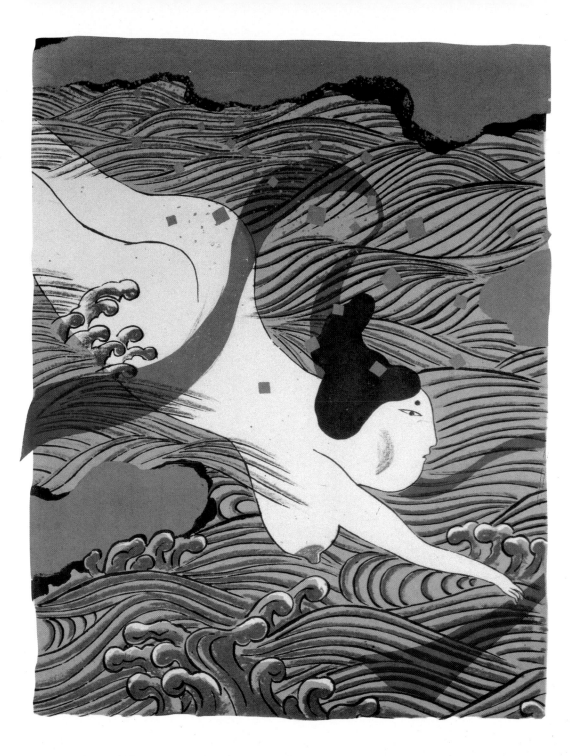

thatch-roofed farmhouse. In Spring, from the second floor of our house, the neighborhood children would stand watch, waiting for larks to start from their hidden nests in the garden and soar into the sky.

Summers, at the time of the Tanabata Star Festival, Mrs. Matsubara would cut a length of young bamboo for us to hang with *origami* animals and lacy paper cutouts. In August, for the Buddhist Festival of the Dead, *O-bon*, we fashioned horses and cows out of twisted cucumber and eggplant, with chopsticks for legs. We filled small paper saddle bags with gifts of cut vegetables and fruit, attached them to the cucumber and eggplant beasts of burden, and stood

Deep Sea

My grandfather often told the children old folk tales. There once was a fisherman named Urashima Taro. One day he saw the village boys harrassing a sea turtle and saved its life. To show its gratitude the turtle led Urashima Taro into the ocean depths to the Ryugu-jo (the palace of the sea dragon). There, Queen Otohime entertained him for many days and nights. He enjoyed himself so much that he forgot all about the time that had passed. When he realized that, he told her that he had to leave. Otohime gave him a beautiful box as a souvenir, but told him not to ever open it. When he returned to his village, everything had changed. He felt lonesome, and of course he opened the box. White smoke came out and turned him into an old man. I felt so sorry for Urashima Taro, but I was fascinated by Otohime and the Ryugu-jo Palace. My grandfather told us that they were too beautiful to describe. Listening to his low voice and staring at the wooden patterns of the ceiling, which very much resembled ocean waves, I tried to imagine that beauty. I was often swallowed into the vastness of the ocean.

(22" x 29") 1975 ed. 30

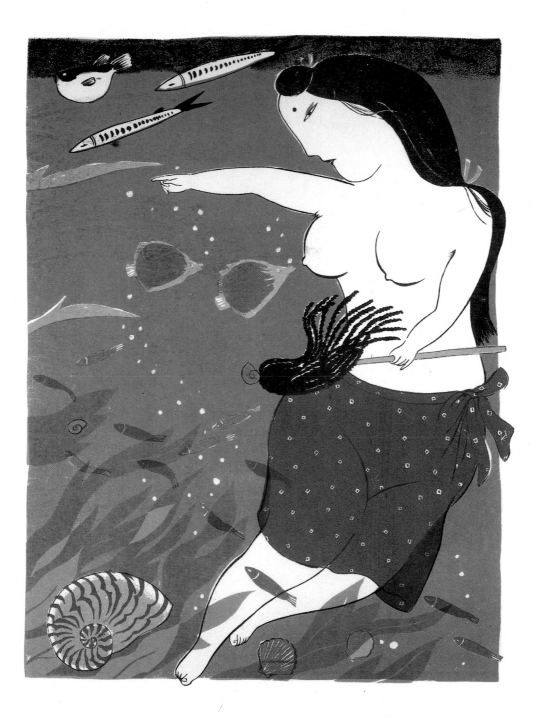

Wind Goddess

Earthquake, flood and typhoon winds were scary events in my childhood. The typhoon blew from the south, east of the China Sea. I do not know why, but usually each one was named a Western woman's name. Radio weather fore-casters would announce: "Typhoon Jane is heading toward Tokyo, with winds up to 60 km an hour and will arrive in Tokyo by midnight. Please shut your rain doors tight and stay home tonight."

(22" x 29") 1970 ed. 50

the little animals around the bonfire lit by the adults to guide the dead back to their domain. Then we leaped back and forth across the fire, a game supposed to bring us health and long life.

Autumn arrived with its own special sights and sounds: the swish and crackle of wheat being threshed by hand; the sudden appearance of orange persimmons clustered heav-ily on the giant persimmon tree in the Matsubaras' yard; the straw lean-to Mr. Matsubara erected around the base of the tree to provide a sheltered, sunny place to work. Autumn was the pickling season; large, white radishes called *daikon* were strung together with straw and hung outside the lean-to to dry in the sun. As the white radishes began to yellow,

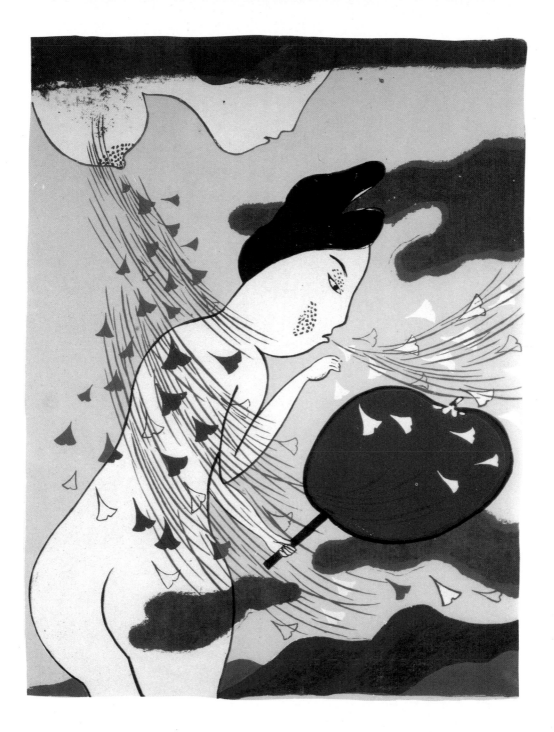

Goddess In Autumn

The old Japanese house I grew up in was made of wood and paper. In Autumn, typhoon winds would rattle the rain doors and whistle through the rooms. All night long we were worried that the wind would break our house, especially when we heard the fire engine. In the morning, we sometimes found some roof tiles among the fallen leaves. The wind is a powerful force and nature is so much bigger than us that we need to pay respect.

(24" x 29") 1974 ed. 35

and give off their special pickle smell, Mrs. Matsubara, sitting just inside the lean-to, would begin paring persimmons to preserve. All the children in the neighborhood loved to sit in the sun and watch her; often she handed us the long persimmon parings to eat. Before we ate the parings, we liked to dangle them to the ground to compare their length with our own height. So skillful was Mrs. Matsubara that a single paring was often longer than we were tall. When she tired of working, she would amuse us by making a tiny sword and scabbard out of a piece of straw. Plucking a loose thread from my sweater, she would place it on my wrist like a trickle of blood, then "wound" me with the straw sword.

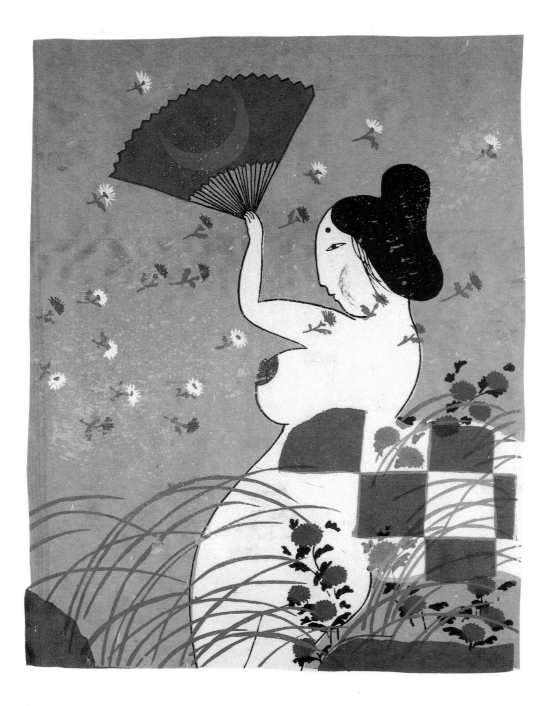

Kannon (Avalokiteshvara Bodhisattva) means a person who sees the sounds of the world and perceives the cries of people in distress. Kannon embodies compassion. She can manifest herself at will to help mortals.

"The sound of one hand clapping" is the famous *koan* from the 18th Century Zen master Hakuin Zenji. You need both hands to make the sound. He says, "Kannon Bodhisattva sees sounds. This is the sound of one hand clapping." When you realize this, you become awake. When you are awake, there are Kannon all over.

(24" x 33") 1976 ed. 75

In December, the neighbors gathered in the Matsubaras' yard to pound steamed rice into the *mochi* cakes we ate at New Year's. At a time in our lives when we were often hungry, the fluffy rice cakes spread out on the earth floor, gleaming whitely in the dimness of the room, were a deeply reassuring sight.

Today, five houses stand on the site of the Matsubaras' farmhouse. The bamboo grove, the persimmon tree, and the small Fox shrine with its red banner, rusty bell, and porcelain figurine have all disappeared into the vastness of the past.

My name, Mayumi, is Buddhist; it means "sandalwood," a hard, fragrant wood used to make Buddhist rosary beads

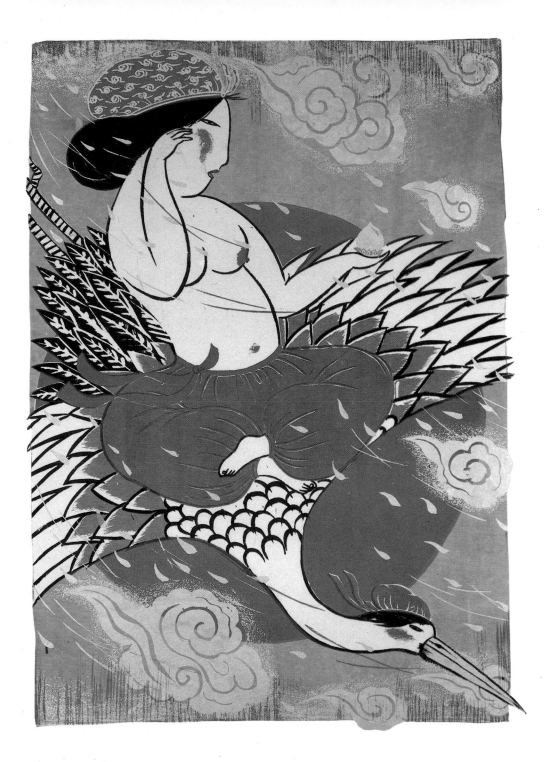

Treasure Ship, She Made the Magic for Their Dream

A part of the traditional Japanese New Year was the appearance of the "dream vendor" on New Year's morning. He would travel from town to town, selling simple woodblock prints of treasure ships loaded with Gods and Goddesses, sacks of rice, jewels and flowers. People would buy the prints and place them under their pillows, in hopes of having a good dream for the coming year.

I wanted to become an artist and imagined making my own book with my illustrations. My parents entrusted their dreams with me: my father's dream to become a Buddhist practitioner, and my mother's dream to become an artist. They worked hard for their children and put us on a treasure ship to sail to a bigger ocean. My brother became a sculptor and my sister became a weaver and the three of us sailed across the Pacific to California. I feel very fortunate that I could insist on my dream and not abandon it.

(24" x 33") 1976 ed. 50

and incense. My grandfather chose a Buddhist name for me in memory of his wife Ai, a devout Nichiren Buddhist and a passionate anarchist or socialist. In the 1910s many Buddhists were involved in revolutionary activities, and I think she was one of them. Long before I was born, Ai had taken her own life, possibly because she was ill with incurable tuberculosis and did not want to give it to her children, and possibly because of her despair with the political oppression of the times. Although the family never spoke about her death, it was clear to me even as a child that everyone had admired her as a woman of great compassion, and as a role model.

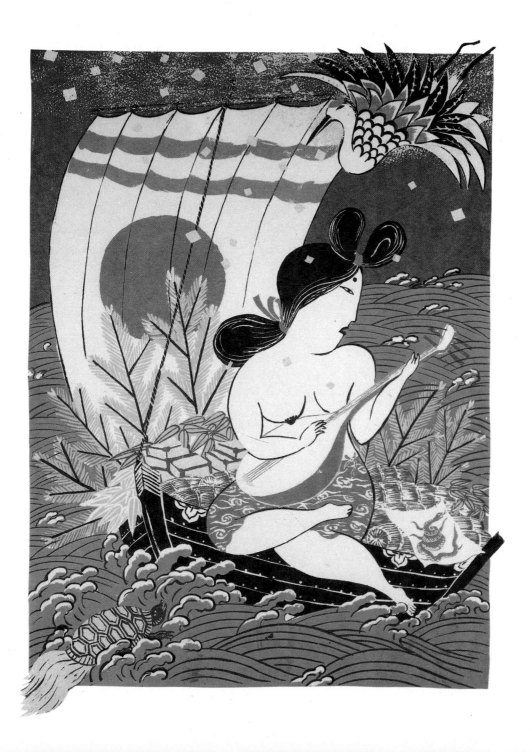

Traditionally, there are seven happy deities aboard the Treasure Ship. Six of these are male, including the Gods of Wealth, Fortune, and Longevity. The sole female is Benten, Goddess of Art and Music.

The shrines of Benten in Japan are always near the water because originally she was the Goddess of the River Saraswati in India. I used to go to Zeni Arai Benten in Kamakura with my cousins. Benten was also the Goddess of Wealth, and Zeni Arai meant "purifying money." Merchant women were bent over the little pond washing money in the small bamboo basket. They offered eggs to the guardian snakes of Benten. I never saw snakes, but people said the eggs were always eaten. At the shrine there was an old man drawing snakes on the paper with one brush stroke. He used a big fat brush soaked with *sumi* ink and went "yahhhhppp!" to the long, white paper from top to bottom, and moving his hand slightly, produced the effect of scales. He did all this in one second! He also read palms and fortunes for the people. He read mine, and placing my small hand over his big, wrinkled hand, carefully read, "You will one day be an artist."

(23" x 32") 1976 ed. 50

When I was growing up, I thought I was raised in an ordinary household—later I realized my family was radical, quite religious, and placed emphasis on the liberation of the soul.

Ai died the nineteenth of May; on the nineteenth of every month, a blind Buddhist monk who had been close to her came to our house to lead a memorial service. Often he was accompanied by his daughter. Before he arrived, my step-grandmother would prepare by cutting fresh flowers from the garden and placing them on the altar, lighting new white candles, and burning incense.

When the monk and his daughter arrived, the whole family would gather in the dim altar room and recite a Buddhist

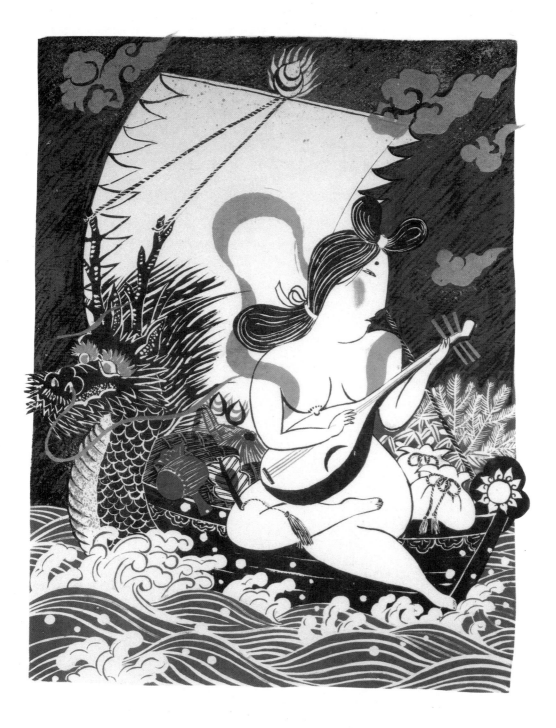

Treasure Ship, Goddess of Flowers

My grandmother was a wonderful seamstress. All the day long, sitting in a sunny corner of our family room, she sewed kimonos and quilted vests for her family. Toward the end of her life she was nearly blind, but she continued sewing until the day she died. When she finished something she would hold it up to me and say, squinting to see the cloth. "What a lovely design for you, Mayumi." We both loved flowered patterns, especially chrysanthemums, peonies, and wisteria.

(24" x 33") 1976 ed. 50

sutra, usually the Lotus Sutra. I would sit on my father's lap and try to follow the difficult text. For the most part, it was incomprehensible to me. But one passage I did understand, perhaps because it appealed so directly to my child's imagination. I can recite it from memory to this day:

Tranquil is this Realm of Mind

Ever filled with Heavenly beings;

Parks and many places

with every kind of gem adorned,

Precious trees full of blossoms and fruits,

where all creatures take their pleasure;

All the Gods strike the Heavenly drums

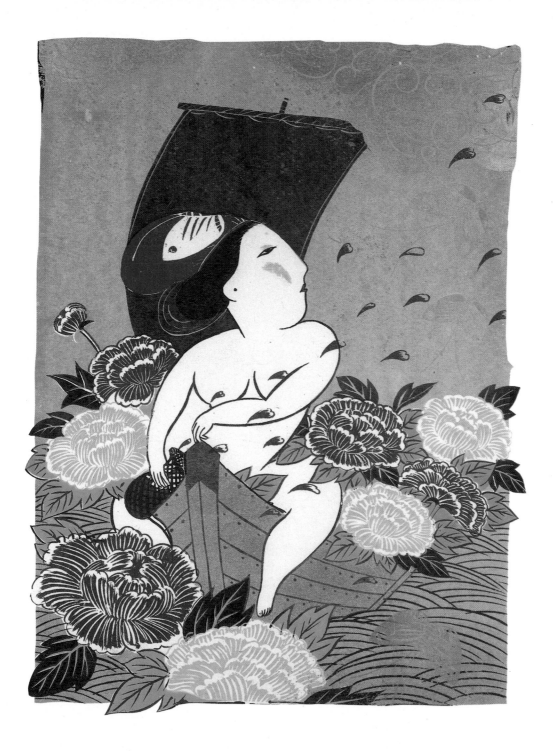

When I see a plant or vegetable growing,
I wonder where it comes from.

I am a gardener but I do not really
garden. Nature is certainly so generous
and fertile, she does the job for us.
George Bernard Shaw once told Alan
Chadwick, "If you want to encounter
God, go to the garden." To me, the
image of the creator has to be female.
Chinese Tao is the mother of the
universe who embraces us all.

I named my house "Spirit of the Valley,"
from the poem in the Tao Te Ching:

> The spirit of the valley never dies.
> It is called the mysterious female,
> Gateway of the creating force.
> It flows continuously.
> Use will never drain it.

(23" x 32") 1976 ed. 50

and evermore make music,

Showering Mandarava-flowers

On the Buddha and his great assembly.

My pure land will never be destroyed.

Sometimes, in the middle of the interminable service, the monk's daughter would call me into the next room and show me how to fold *origami* cranes. She was wonderfully deft, her fingers slender and delicate. I liked to test her by insisting she make the cranes smaller and smaller. She would always oblige, beginning with one the size of a matchbox and working her way down until she finally

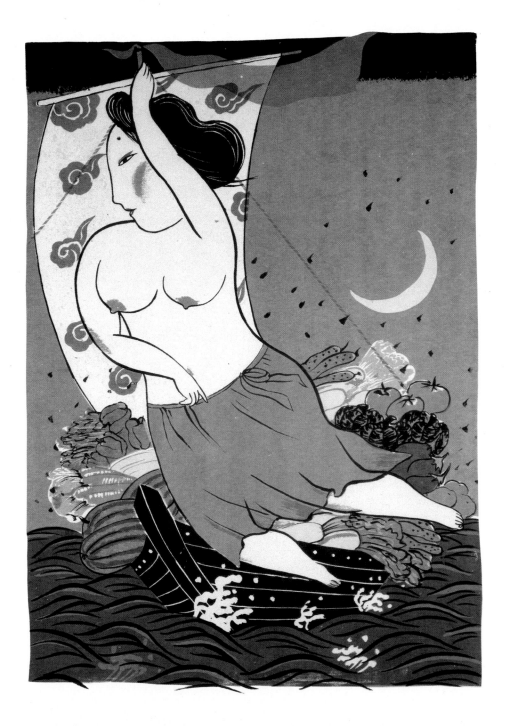

I wrote this for the announcement of
my exhibition for the treasure ship
series in 1978:

> Long Night—
> from the distance of deep sleep
> I awake and see,
> the Benten Goddess—

These days I keep hearing a song I had
to practice on my *shamisen* when I was
five and six, but could never
understand. Especially when I am in
America, on my farm in Princeton, early
in the morning when the sun lifts into
the sky from the distance of the horizon,
the treasure ship in that song sails
toward me in a vision. When that
treasure ship arrives I dream of loading
it with rice and vegetables, wild flowers,
beasts, and the people I love, and then
setting sail toward the light in my lucky
direction. I am at the helm.

(23" x 32") 1976 ed. 50

folded a crane no larger than a kernel of rice. Meanwhile,
the chanting droned on in the next room: *Nam myo horenge-
kyo, nam myo horenge-kyo. . .*

In those days we had a pond in our garden, shaped like
a gourd. Every summer, the goldfish vendor would wheel
his cart past our house, and my grandmother would buy
each of us four children a goldfish. It was my job to feed
them; squatting at the edge of the pond, I would summon
the fish to the surface by clapping my hands, then throw
them leftover rice. Toward the end of the war, when Tokyo
was being bombed, my grandfather filled in the pond and
built an air-raid shelter beneath it. Huddled in the shelter

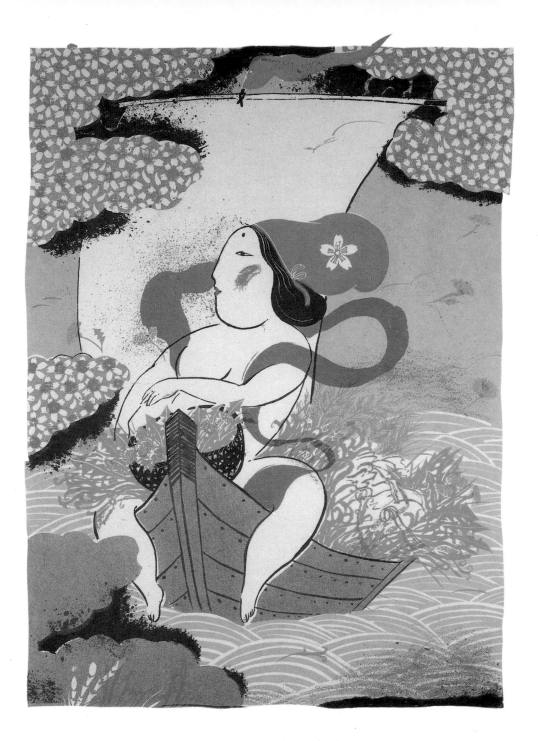

**Al Huang is a Tai-chi master and a
wonderful self-taught flutist. His
ancient bamboo flute came to him
through many many people's hands.
This flute had an amber color and was
almost transparent. One day he played
it for me and I painted him as the
Goddess. I hope he doesn't mind.**

(23" x 30") 1976 ed. 50

in the middle of the night, I would watch the winking lights
on the B-29s as they flew overhead—the lights in the dark
sky looked to me like the Devil's eyes and filled me with fear.
My earliest memory is having tantrums in my crib, being
very, very angry. I wanted to be somewhere else, where it
was peaceful; my mother could not soothe me when air-raid
sirens filled the air. We finally were evacuated to Iwate, in
the north of Japan.

The "new democracy" of the post-war years in Japan was
supposed to include equality for women; but it was clear to
me that women were still treated as second-rate citizens, or
worse. Japanese women speak a women's language which

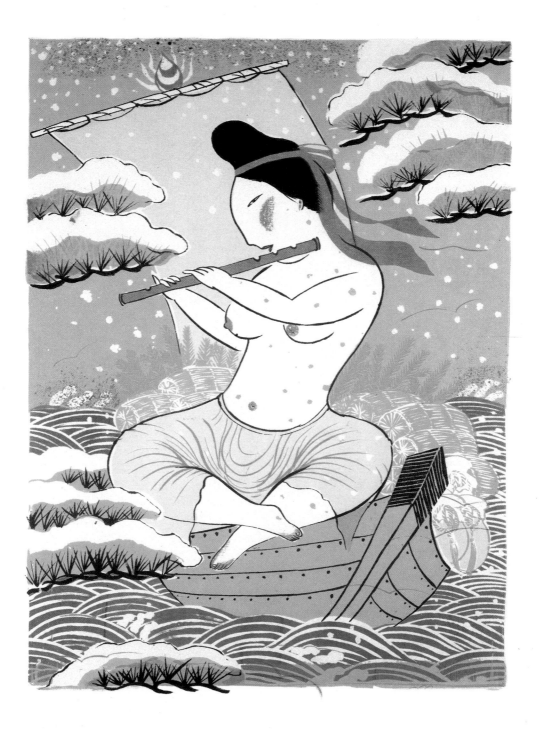

Thunder Goddess

There are famous paintings of the Thunder God and the Wind God by the 17th Century painter Sotatsu. These Gods are angry and frightening. I simply transformed them into Goddesses.

Sotatsu derived many of his ideas from 12th Century picture scrolls. He took some of the scenes and placed them on big, gold screens. Great masters are in our tradition, and no art is original and sacred. As a 20th Century woman, I like to see women as vital and powerful beings. I could not find those images in art history books, so I had to create them.

(26" x 38") 1977 ed. 50

is "lesser" than the male language, so automatically you are less than a man. This kind of reality was difficult for me to accept, because what I experienced at home and what I learned in school and outside of my home, were different.

When I was in the sixth grade, our female teacher told the girls to remain after school one day. When the boys had left the room, she lectured us briefly on menstruation, her voice hushed and embarrassed. That gruesome "kit" and the diagram of the womb she drew hurriedly on the blackboard, made me feel somehow shameful and unclean.

The day I got my first period, my mother prepared *o-seki-han*, rice steamed with red beans, an auspicious dish reserved for celebrations. The special rice was served to the

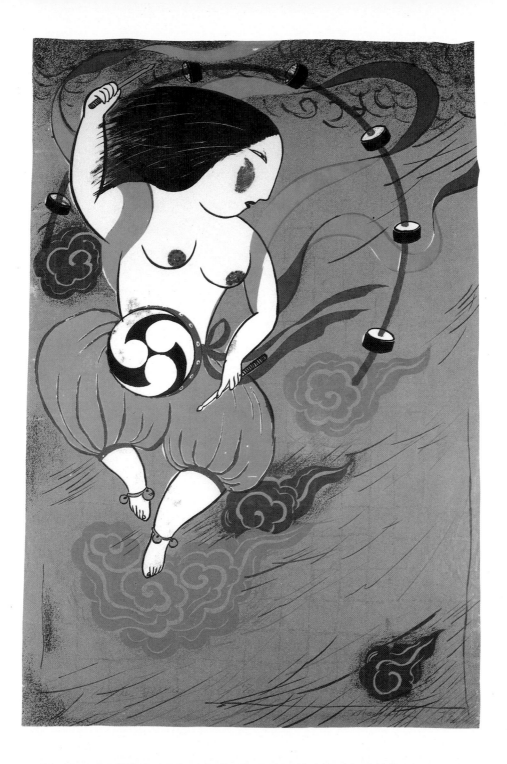

I do not think of myself as a feminist, but I believe in the strength and vitality of the female. We are creators and our maternity comes out of a universal womb.

The reason that I could not become completely involved in women's liberation during the sixties and seventies was that I found that their attitude was to blame men and society. Society has mistreated women for many thousands of years. I felt men themselves were mistreated too. Rather than blaming the problem on others, we can find our resources and our strength in ourselves.

(26" x 38") 1977 ed. 50

family without a word of explanation, to keep the other children in the dark—it was an unspoken ritual for the adults, a silent "celebration" of my passage to womanhood.

My mother had wanted to be an artist, and she taught me the joy of creativity. She made the great effort necessary to buy materials for me and send me to art lessons. When I was eleven years old, she took me to see Siko Munakata's woodblock exhibition, where I saw his Ten Disciples of Buddha. My mother transmitted her love of art to me by holding my hand and going over each print. She was still young and beautiful, and her full white face seemed to resemble Munakata's Kannon Bodhisattva. She then took me

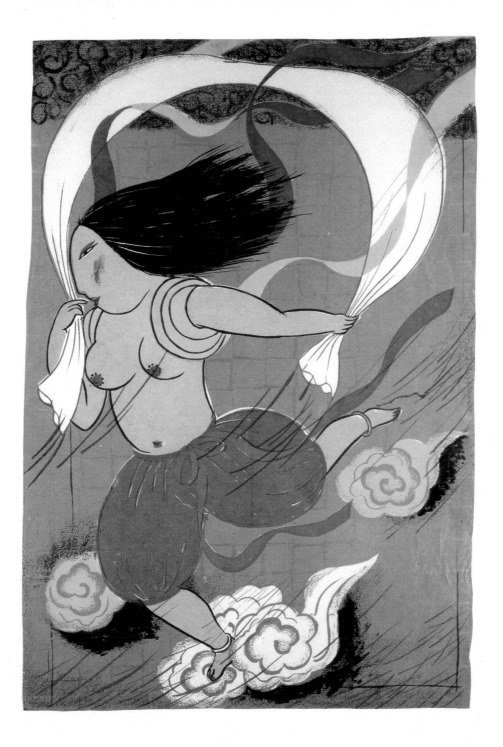

In my early teens, my father took me to one of the big department stores to see the *Ukiyo-e* (traditional woodblock prints of the floating world). They made such a strong impression on me that I wanted to draw exactly like them. I love Harunobu, Hiroshige, Hokusai and Utamaro very much, and now I feel that they paint with me.

(15" x 21") 1975 ed. 30

to the cafeteria and bought me vanilla ice cream. Licking the silver spoon, I dreamed about my adult life as an artist and made a vow that I would make my mother happy.

My father was a Zen Buddhist and historian. At the dinner table, he would give me the teachings of Zen. To him the most important thing was concentration. He often told a story about Tozan, a very well known monk, who was asked, "What is Buddha?" Tozan, who happened to be weighing hemp, answered, "Three pounds of hemp." As a child I didn't understand what it meant, and it is still quite a difficult *koan* or Zen riddle. But that was my father's teaching. He said, "Concentrate. Be here now." That's it.

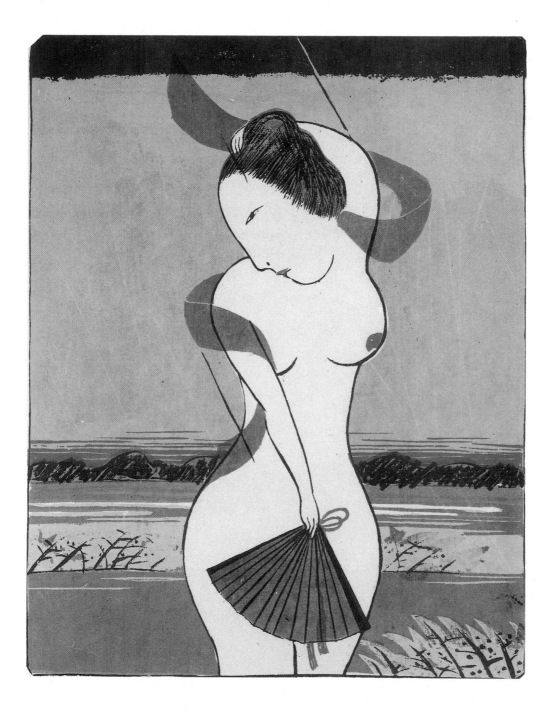

Green Mountain

For the Japanese, Mt. Fuji is the sacred spirit itself. We could see it especially in the clear early morning from the upstairs window of my parents' house. Mt. Fuji gave me a feeling of tranquility; I understood why Hokusai painted thirty-six views of it.

(16" x 20") 1975 ed. 50

In junior high school, to my grandmother's dismay, I liked to play and especially to fight with the boys in the neighborhood, and was constantly being admonished to "behave like a girl!" I was known as "Miss Tarzan," because of my habit of climbing onto roofs and into trees. To spend time alone on a roof or high in a tree gave me an exhilarating sense of liberation. It was there, perched high above the neighborhood, that I began reading Colette and George Sand. I am not sure what precisely in those writers attracted me so; what I do know is that the image of women I found in Japanese literature—somehow unclean and ashamed— was repellent to me.

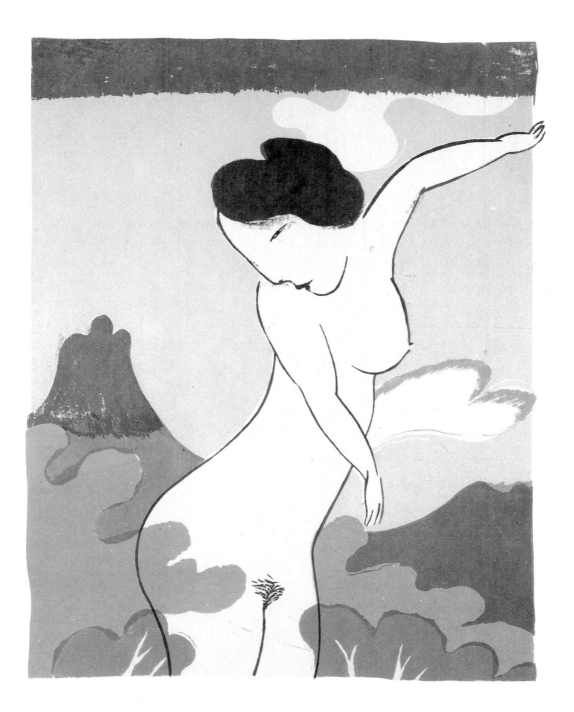

Victorian Invention. Bicycle

All through high school I felt confined; imprisoned inside my blue uniform, except when I rode my bicycle to and from school, a five mile journey through fields and paddies. Whenever I had time I would get off my bike in the middle of a cabbage field and take a deep breath—that was always a moment of liberation.

(16" x 23") 1977 ed. 50

I went to a girls' high school. Dreams of marriage filled the heads of most of my classmates. They looked forward eagerly after graduation to preparing themselves for marriage by studying tea ceremony, flower arranging, and cooking. Their unquestioning acceptance of this "happiest of possible futures" for a young woman in Japan made me angry; I could not like them.

I did have one good friend, Kazuko. Her elder brother was the ideological leader of the leftist student movement and was translating the collected works of Trotsky. He would often shuffle into Kazuko's room when we were doing our homework, a wrinkled, old cap pulled down over

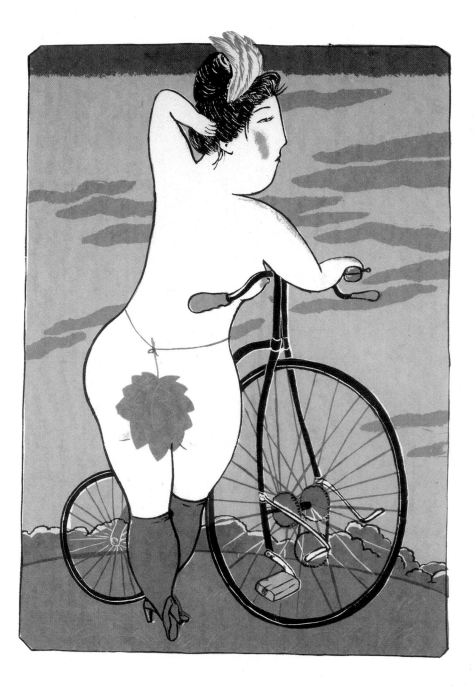

Victorian Invention.
Bell Telephone

We owe our convenience and comfort to many 19th Century inventors. Without Alexander Graham Bell, many people could not exist today.

Nearly all the inventions we use in our everyday life date from the last half of the 19th Century: typewriter, phonograph, automobile, train, etc. The kind of lonely struggle these inventors went through must have been extraordinary. I can feel the excitement and the disappointment they must have felt, and admire their persistence in making their dreams a reality.

(16" x 22") 1977 ed. 50

his head and his eyes hidden behind the dark glasses he always wore, to give her books he wanted her to read. It was at this time that I too began reading Sartre and de Beauvoir. Often, Kazuko and I ditched school and went to see films by Cocteau and the New Wave directors appearing in Japan at that time, Truffaut and Godard. Kazuko and I considered ourselves very much a part of the avant-garde. She turned to politics; I began to prepare in earnest to enter the National Academy of Art.

The entrance examination was notoriously difficult. In those days, one out of thirty applying students was accepted. To have even a hope of passing, one had to be able

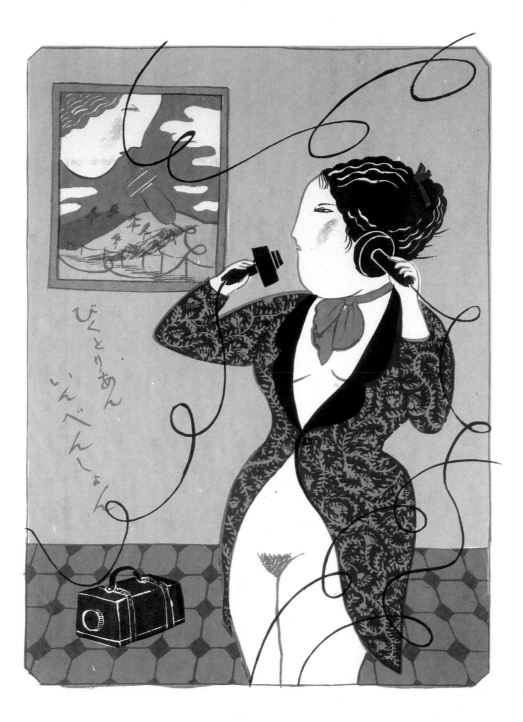

I love to watch people rollerskate.
Especially on a sunny Sunday, many
people are out in Golden Gate Park in
San Francisco, dressed in various
clothes, floating through the empty
roads.

The pedspeed was introduced circa
1870. I saw an engraving of two ladies
on their wheels, hand-to-hand skating,
and a gentleman greeting them and
taking his hat off. The ladies were
wearing tight clothes. I thought they
would have enjoyed it much more if I
let them skate in their camisole and
bloomers.

(16" x 22") 1977 ed. 50

to draw whatever one saw or could imagine: hard things,
soft things, shiny, transparent, fluffy things—anything and
everything. At home, I worked hard for two years, drawing
everything in sight: a lacy cloth covering a child's tricycle,
flowers in a vase and a piece of fish, a honey jar alongside
a piece of crinkled tinfoil, an apple reflected in the foil. On
my third try, I passed the entrance exams and was admitted
to the Academy in the department of Arts and Crafts. But
the Academy's approach to art was stifling to me; I felt disap-
pointed, and trapped.

While I was still in my freshman year I met John Nathan,
a young American who had just graduated from Harvard

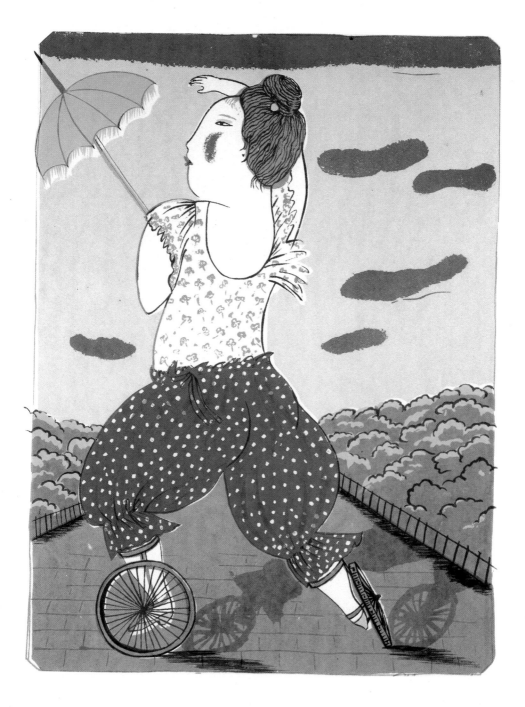

42

Victorian Invention.
An Aerial Cycle

I have a book called *Victorian Invention*, by Leonard De Vries, in which I found a picture of an aerial cycle. Among all the other incredible inventions, someone actually tried to make an aerial cycle, and to our disappointment did not succeed. I feel it is very important to insist on our dreams.

(16" x 22") 1977 ed. 50

and was in Japan studying Japanese literature. John spoke fluent Japanese; we spent hours in coffee shops all over Tokyo, talking and talking. When I told my parents that I wanted to marry him, they consented, but made me promise to remain in Japan until I had finished school.

We were married in October 1962, and lived in Japan until the spring of 1966. John had a Honda motorcycle. We bought helmets, a red one for me, a white one for him; and we rode to school together. We listened to modern jazz—Thelonious Monk, Miles Davis, John Coltrane; and at night John read me James Joyce and William Faulkner. Sometimes he would play his recorder and I would sing Joan Baez and

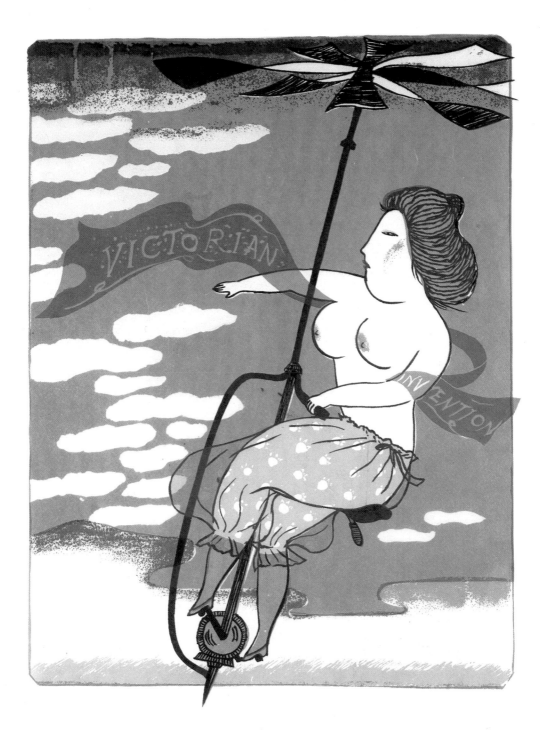

Aphrodite

How do I approach Aphrodite? I give myself golden skin and long black hair and I am Aphrodite herself. I let the Aegean Sea and the South Wind wash me to Cypress. All of us create our own legends.

Sappho said:

> You may forget but
> Let me tell you
> this. Someone in
> some future time
> will think of us.

She knew that she was creating her own myth.

(23" x 32") 1978 ed. 60

Bob Dylan songs. I was living like an American. And I felt free—free of my family, my school, and especially free of my Japanese womanhood. I felt that John held the key to my liberation.

After we graduated from the university in 1966, we moved to New York. The heavy clouds of the Vietnam War were hanging over us. John wrote a column called "Notes from the Underground" in the *Evergreen Review.* Allen Ginsberg and flower children, Timothy Leary and his psychedelic light show, movements to legalize abortion and pornography were filling my life. I met many artists, some of whose names were familiar to me before I came to

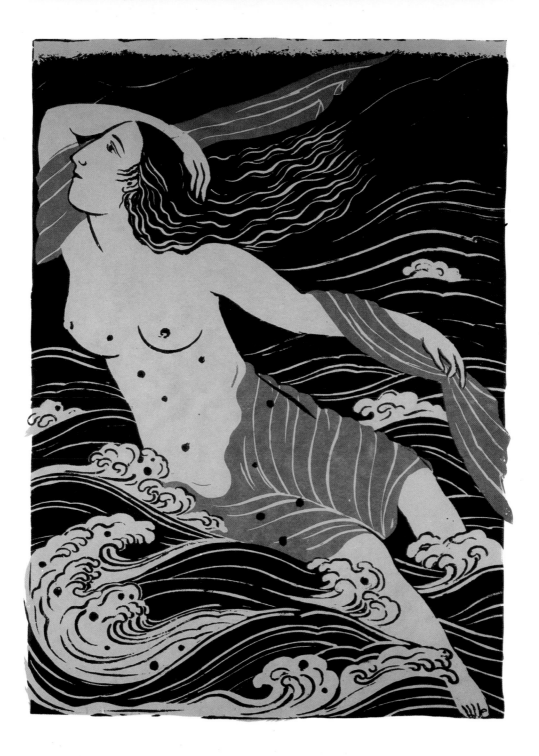

Cherry blossoms are the best loved flowers in Japan. I invited a dancer out of a 16th Century Japanese screen to join my flower viewing party. I asked her to take her costume off to enjoy the thick full blossoms and falling petals.

(22" x 29") 1971 ed. 50

America. Mark Rothko and Willem de Kooning were the most powerful I met. De Kooning's paintings were so violent, so full of raw passions, that when I was in his studio surrounded by them, I could not breathe. Rothko told me that he often read Shakespeare. Later, when I learned about his suicide, I understood what he had meant; his paintings were so intensely sad and burdened. I knew right away that I could not be a painter like them. I said to myself, "I am small." "I am Japanese." I kept questioning myself, "What is my art?"

In 1967, in New York, I gave birth to my first son, Zachary Taro. My second son, Jeremiah Jiro, was born in Cambridge,

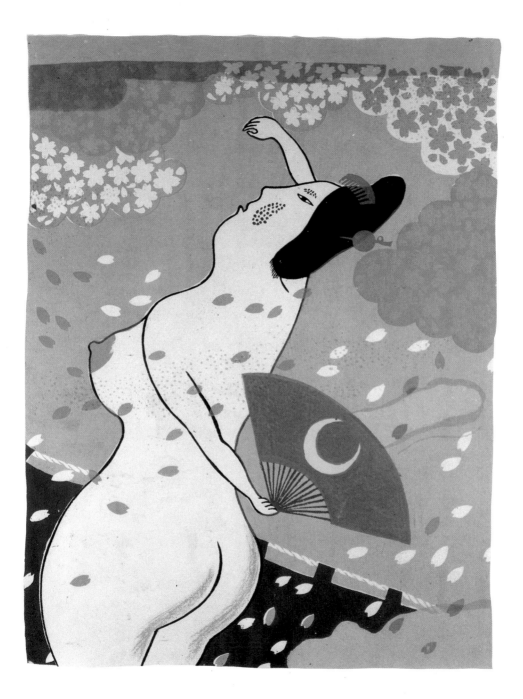

Spring Goddess

When the fire-bombing of Tokyo began, my mother and I fled to the north country. In the Spring, we would go to a hill near a river bank to pick wild plants and eat horsetails, ferns, and wild chives. I hated the plant stain on my fingers; the strong fragrance of the wild north stayed with me.

My parents now live in Kitayama, North Mountain, in Kyoto. My mother gets up at dawn and walks through a cedar forest every morning with her friends. Her botanist friend taught her the names of the wild flowers. Sometimes she picks a few and comes back home to sketch them. Once in awhile I receive a picture postcard from her with these flowers on it.

(22" x 29") 1974 ed. 35

Massachusetts, in 1970. My studio in Cambridge was in the dark basement of our Victorian house. Whenever I could steal time from house work and caring for two small boys I would rush downstairs to work. It was in that dim basement beneath the deep Boston snow that I began silk-screen prints of women in exorbitant color. Working there in my basement, I felt that I had reclaimed myself.

The women's liberation movement was just beginning in those days, and everyone was full of excitement and energy. Women felt victimized by men and society, and they were angry. I was angry, too. But the experience of giving birth and raising children and being an artist at the same time

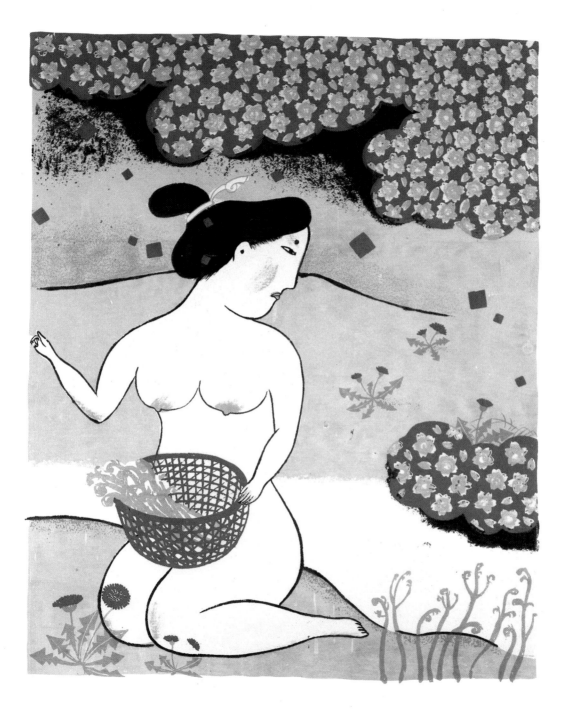

Rain in May

When I was in the first grade, I drew a picture of myself singing in the rain with my new umbrella and black rubber rain boots. The picture won first prize in the school art show. Then I announced to my family that I would be an artist when I grew up.

Every summer vacation we had to keep a picture diary each day. At the end of the day, children sat at the living room table and my mother would ask, "What do you want to draw for today? Anything memorable?" My brother would answer, "I went to the river to catch crayfish." I would say, "Grandmother's morning glory had its first flower." Drawing the pictures for my prints is not so different from when we were children. Some people ask me when I started drawing. I say, "I never stopped drawing."

(22" x 29") 1975 ed. 35

made me realize my own strength and the potential power of all women. Deep inside me a voice was saying, "We are strong; we must only realize our own strength."

Nonetheless, I continued to follow John wherever he went. When he took a teaching job at Princeton, we moved there. We lived in an 18th Century farmhouse in the middle of a soybean field, and my studio was in the attic. From the attic window I could watch the seasons change, much as I had done when I was a child. In the Spring, as the heavy snow melted, wild daffodils burst from the wet ground and crab apples, double-petaled cherry trees, magnolia and pink and white dogwood drenched the town in color. Every

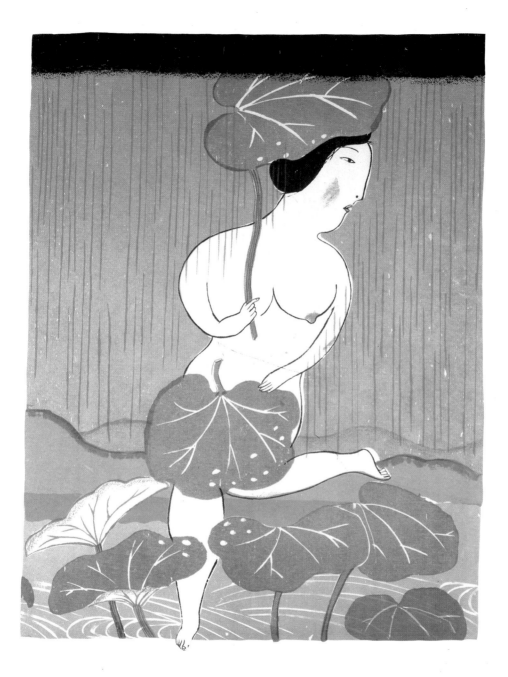

Spring Meadow

The explosion of color and energy in the Spring has always thrilled me. Walking through a flowering field, I feel one with the world.

(22" x 29") 1975 ed. 35

Summer we had a vegetable garden: tomatoes, corn, green pepper, lettuce and beets all Summer long. In the Autumn the maple trees turned yellow and a combine came to harvest the soybeans in the field.

I was working hard, my sons were growing up, and life in general seemed peaceful enough. But I could sense that John and I were growing apart. He is Jewish and intellectual, I am Japanese and emotional. Married for fifteen years, we were close but so different. I felt how East and West never met, or how man and woman never met. All my life I have been seeking liberation, but from what? I felt I didn't know. I began reading in Japanese again, and discovered two

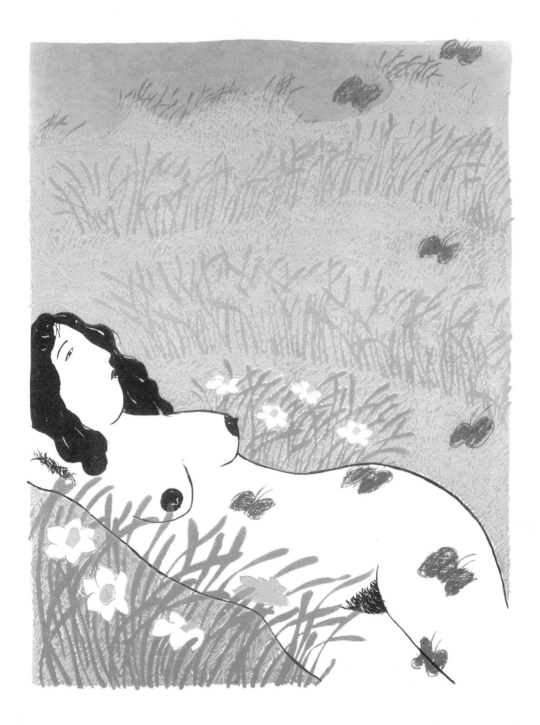

Takeojima Island is famous for the
shrine of the Benten Goddess (Goddess
of art, music and wealth) and the many-
centuries-old well-kept lacquer wares.
They are usually decorated in deep red
and black. They have patterns of
rabbits, which are considered to be in
the moon, pounding *mochi* rice cakes,
jumping over the ocean waves.

(15" x 20") 1977 ed. 30

women writers, Raicho Hiratsuka and Kanoko Okamoto,
who became very important to me. Both were Buddhists,
and both had discovered through Buddhist practice a source
of vital power within themselves which they identified as a
long-forgotten female vitality and strength—the creative
power of Primeval Woman. Raicho Hiratsuko wrote in 1911
for the introduction of a new feminist magazine called
SEITO, which means Blue Stockings, from the English
feminist movement.

In primeval times, women were one with
the sun and truth of all-being.
Now we are like pale-faced moons who
depend on others and reflect their light.

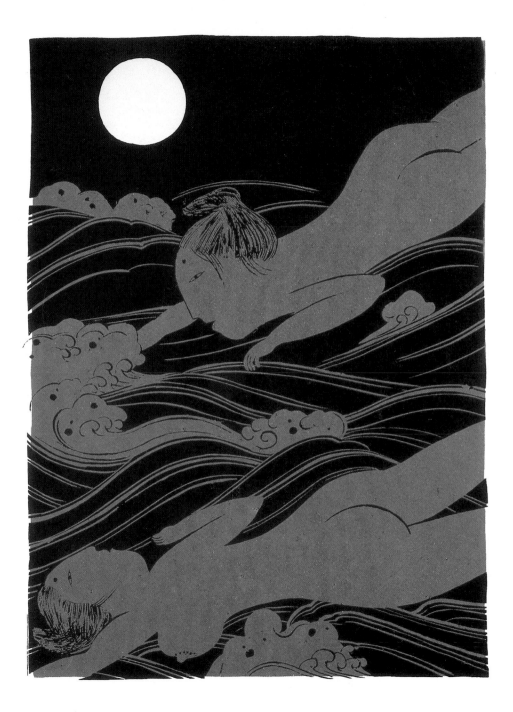

Goddess Coming to You; Can You Come to Her?

Repeating the name of Kannon Bosatsu (Avalokiteshvara Bodhisattva) hundreds and thousands of times, people eventually get in touch with their own source of energy and compassionate self. This is the simplest, probably the most powerful Buddhist practice. Kannon Bodhisattva is liberating universal energy, and your belief in her makes you a Kannon Goddess.

(24" x 33") 1976 ed. 75

Women, please let your own sun, your
concentrated energy, your own submerged
authentic vital power shine out from you.

We are no longer the moon.
Today we are truly the sun.
We will build shining golden cathedrals
at the top of crystal mountains, East of
the Land of the Rising Sun.

Women, when you paint your own portrait,
do not forget to put the golden dome at
the top of your head.

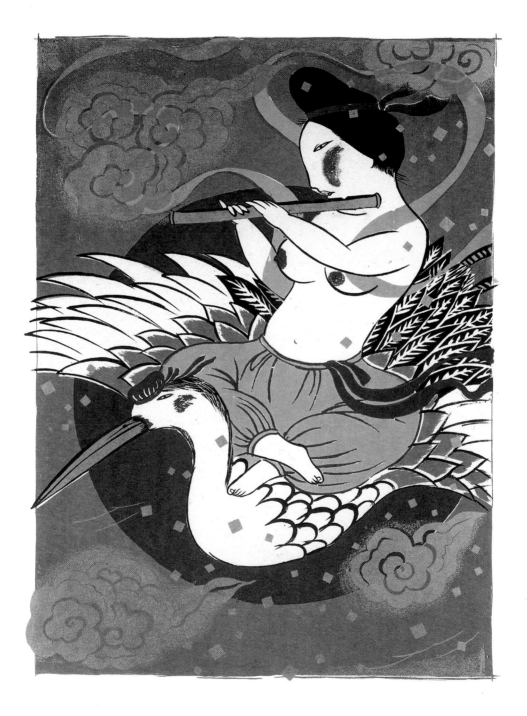

Pearl Diver

When I swim, I am a fish, I am a wave, I become a sea.

I was afraid of water. The river and ocean were so powerful and I feared that I would be swallowed up—yet I had a tremendous urge to become one with them. After all, 96 percent of us is water. I recently learned scuba diving, and the undersea world opened for me. It is probably the closest thing to flying and gives me a sense of exhilaration.

(26" x 36") 1977 ed. 50

As I read their novels and essays, written before the war, I began to feel in touch with my own power as a woman. It was as if a sun inside me had finally broken through the clouds. Goddesses became my theme, and silk-screened prints of Goddesses seemed to create themselves.

In 1978 we spent a year in Tokyo and I began to practice *zazen*, Zen meditation. I felt compelled to know myself more deeply. When we returned to the United States I decided to continue my Zen practice and moved to Muir Beach, next to the Zen community at Green Gulch Farm. John moved with me, but not long after, we separated.

Living my own way for the first time, my life begins at last to make sense to me. To work and meditate and paint

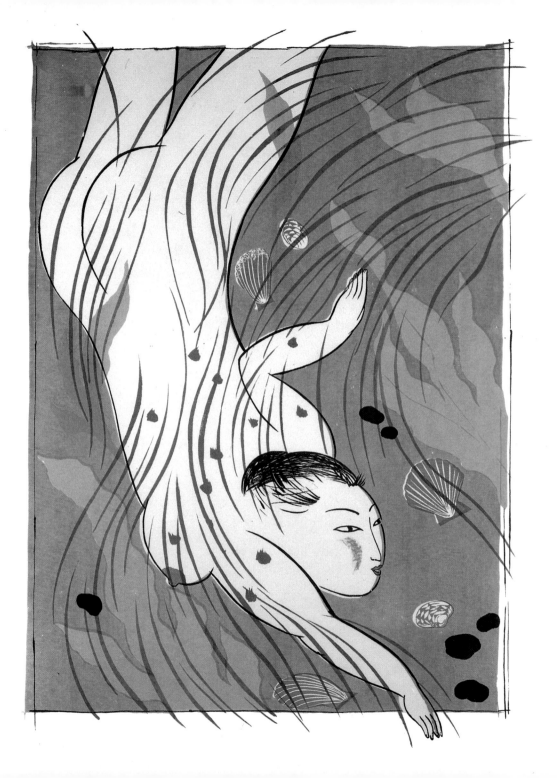

Goddess of Love

Aizen Myōō, *Ragarājā,* is a God of penetrating love, and is always depicted as an angry figure. His anger reminds us of the power to transform desire and passion into compassion. My Goddess of Love is the inspiration of love itself.

(25" x 37") 1980 ed. 40

on the Zen farm comes naturally to me; it takes me back to the life I led as a child. I am often totally alone, but never lonely.

One day not long ago, I had a dream:

I am sitting quietly in the middle of a vast field which leads to the beach.

John is sitting at my right hand, my two children at my left. Standing around and behind us, as in a family photo, is everyone in my life who has been important to me: my mother and father, my grandparents, my real grandmother Ai, my art teachers, Richard Baker Roshi, friends from Green Gulch farm, from New York, Cambridge, Princeton,

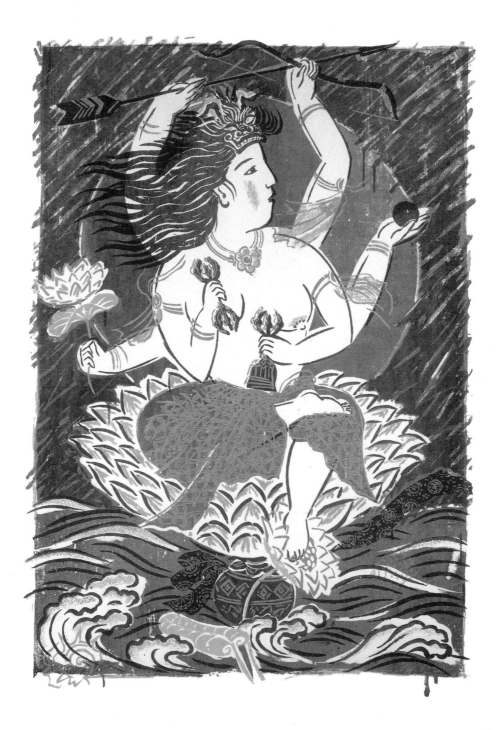

Samantabhadra

Samantabhadra is the shining practice Bodhisattva. She turns meditation into action and dream into reality. We tend to think there is someone out there to help us do this, but unfolding the path completely depends on ourselves. When we become Samantabhadra herself we can freely ride this wheel of dharma and receive wonderful support from people, friends, and teachers.

(29" x 40") 1980 ed. 48

and Tokyo; even our old horse Patches is there, and our dead dog, Jessie. White clouds are floating in the sky; surf breaks against the beach. A fountain of tears is streaming from my eyes. But I am smiling.

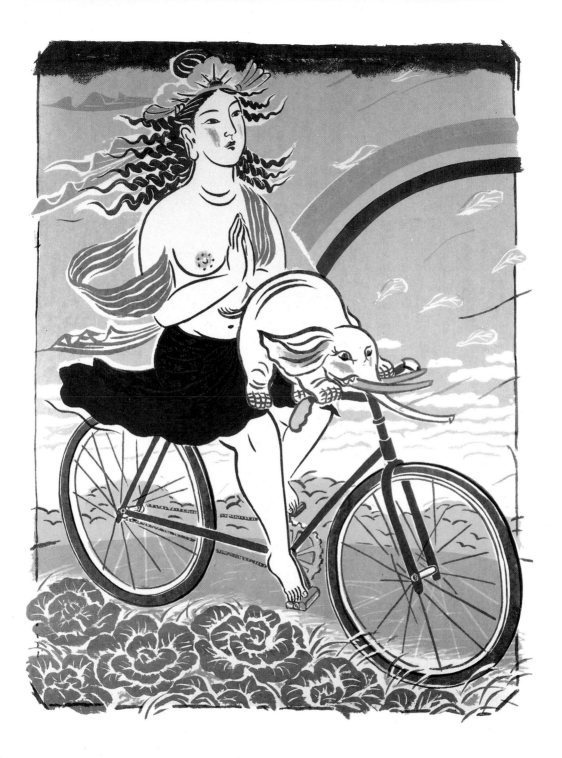

Photograph by Chris Stewart

Seven years ago Lois Lancaster, art director of Lancaster-Miller Publishers, approached me to do an art book. All summer long I worked writing the text for it. The title *Goddesses* popped out of my head. I thought it was a pretty cute title, and I had no idea that anybody else was interested in Goddesses. Right after the publication I noticed that something was going on. Lots of other people were also talking about Goddesses. I realized that I had stepped into a bigger and deeper place, more like an ocean of people's collective unconscious.

Images of Goddesses came to me at the birth of my first son Zachary. It was the late 60s in New York and the dark clouds of the Vietnam War were hanging above us. I needed

a vision that would give me power to live and to create. I had a strong urge to paint large-breasted female figures. I was working on etchings, and from the black, aqua-tinted background, Goddesses emerged like Hesiod's description of the birth of Gaea. "There was chaos, vast and dark. Then Gaea appeared, the deep-breasted Earth." Sometimes my Goddesses burst from the sea like Venus, and sometimes they floated in the night sky.

I had my second son Jeremiah in 1970. Between taking care of two children and the house, I had very little time to create. I felt like I was going to lose myself. Out of desperation, my art became a survival force. Without creating art, I couldn't be myself. The children forced me to see who I was. Being an artist wasn't a luxury anymore. I needed to see myself as positive and strong. Through creating Goddesses, I became stronger. Art was a means for survival.

Goddesses are a projection of myself, my desire and my dreams. They help me to see who I am and who I want to be. Through my creative process, I have been creating myself.

I have lived in the United States for twenty years. During those years women, especially women in this country, have gone through a lot of change. The peace movement... psychedelic times... women's liberation... divorce... spir-

itual quest. We have had to learn so much and we have had to unlearn so much. We have had to explore and experiment. Since we have not had any role model to follow, we have had to create our own culture. I feel fortunate that I participated in this process, and at the same time, found my own Japanese roots.

Through this book of Goddesses, I met many people. Some taught me. Some inspired me. But more importantly than that, we empowered each other by who we are.

I met Ruth Gottstein of Volcano Press two years ago. She came to many of my exhibitions and lectures and we got to know each other. We talked about how women of different professions had done the legwork for so many years and now we were ready to work for ourselves. When she offered to publish a revised edition of *Goddesses* as the first of a series called Kazan Books (*kazan* means "volcano" in Japanese), I felt it was completely appropriate to work with her. The name "volcano" was the symbol of the re-emergence of Goddesses. Everything fit into place.

Milleniums ago, Goddess culture was on this earth. We women were the sun and truly the creators. With the progress of civilization God became stronger and Goddesses were suppressed to the level of society's unconscious. Goddesses have had to sleep for thousands of years.

This book came out of my unconscious and together the book and I continue to grow. Many people have become part of it; not just women, but many men too. I revised this text to make it more current.

Goddesses are in each of us. My friend Peter Levitt—pointing to his legs—said, "These are the legs of Goddesses." I want all of us to have the legs of Goddesses to firmly root us to this earth. Earth is crying for her recovery.

Here I would like to express my love and gratitude to all those who encouraged and inspired me over the years.

Yasumasa Oda
John Nathan
Zachary Taro Nathan
Jeremiah Jiro Nathan
Bill Coldwell
Richard Baker
Peter Kaufman
Sachie Oda
Kazue Mukai
Roberta English
Elsa Gidlow
Virginia Lewis
Thich Nhat Hanh
Dainin Katagiri Roshi
Masanobu Fukuoka

Thank you.

Last, a special thank you to Barbara Noda and to Ruth Gottstein of Volcano Press, who helped me to put together this revision.

Mayumi Oda
Muir Beach
1988

1966 Graduated Tokyo University of Fine Arts

1966-8 Studied Pratt Graphic Center, New York

1969 One-Woman Show, Adams House, Harvard University

1970 Tokyo International Print Biennial

1971 22nd National Exhibition of Prints, Library of Congress

1972 Third British International Print Biennial, Bradford City Art Gallery

 New Talents in Printmaking, Associated American Artists, New York

 One-Woman Show, Yoshii Gallery, Tokyo

1973 One-Woman Show, Art/Asia Gallery, Cambridge

 Tenth International Exhibition of Graphic Art, Ljubljana, Yugoslavia

1974 Modern Japanese Print Show, Cultural Center, New York

 Two-Women Show, Contemporary Asia Art Gallery, Washington, D.C.

1975 24th National Exhibition of Prints, Library of Congress

 One-Woman Show, Mukai Gallery, Tokyo

 One-Woman Show, Art/Asia Gallery, Cambridge

1976 One-Woman Show, Upstairs Gallery, San Francisco

 One-Woman Show, Franell Gallery, Tokyo

 Two-Woman Show, Ankrum Gallery, Los Angeles

 One-Woman Show, Gallery Humanite, Nagoya

1977 2nd World Print Competition, San Francisco

 One-Woman Show, Art/Asia Gallery, Cambridge

 One-Woman Show, 24 Sather Gate Gallery, Berkeley

1978 One-Woman Show, Mukai Gallery, Tokyo

 One-Woman Show, Gallery Humanite, Nagoya

1979 One-Woman Show, Mary Baskett Gallery, Cincinnati

1980 One-Woman Show, Ankrum Gallery, Los Angeles

 One-Woman Show, Satori Collection, Portola Valley

1981 One-Woman Show, Satori Gallery, San Francisco

 One-Woman Show, The Tolman Collection, Tokyo

 One-Woman Show, Galerie Petit Formes, Osaka

 One-Woman Show, Gallery CoCo, Kyoto

 One-Woman Show, Suzuki Graphics Gallery, New York

1982 One-Woman Show, Satori Gallery, San Francisco

 One-Woman Show, Goddesses: Visions of Woman, Commons Gallery, University of Hawaii Art Department

 One-Woman Show, Tucson Museum of Art

 One-Woman Show, Queen Emma Gallery, Honolulu

 Group Show, Japanese Prints Today, California Polytechnic University, Pomona

1983 One-Woman Show, Satori Gallery, San Francisco

 One-Woman Show, The Tolman Collection, Tokyo

 One-Woman Show, Mukai Gallery, Tokyo

 Group Show, Galerie Marina Dinkler, Berlin

1984 One-Woman Show, Art Front, Zurich

Group Show, Humour in Contemporary Art, The Museum of Modern Art, Saitama

Three-Person Show, Year of the Ox, Roberta English Gallery, San Francisco

Group Show, Shackleford-Sears Gallery, Davis

Group Show, American Women Artists; One Hundred Years of Original Prints, Tahir Gallery, New Orleans

1985 Artist-in-Residence and One-Woman Show, Institute of Culture and Communication, East-West Center, Honolulu

One-Woman Show, The Tolman Collection, Tokyo

One-Woman Show, April Sgro-Riddle Gallery, Los Angeles

Group Show, Galerie Scheidegger, Zurich

Group Show, Zeitgenoessische Japanische Original Graphics, Scheidegger, Zurich

Group Show, When the World Changed: Japanese Prints from the 19th and 20th Centuries, University Art Museum, Berkeley

Group Show, Star Festival, Pacific Asia Museum, Pasadena

1986 One-Woman Show, California Buddha Field, Ginka Gallery, Tokyo

One-Woman Show, Vision of Yin, Antonio Prieto Memorial Gallery, Mills College, Oakland

One-Woman Show, Roberta English Gallery, San Francisco

Group Show, Shackleford-Sears Gallery, Davis

Group Show, Long Beach Museum

One-Woman Show, Central Gallery, Osaka

1987 One-Woman Show, Honolulu Academy of Arts, One-Woman Show, Cather-Award Gallery, Portland

One-Woman Show, Cathedral of St. John the Divine, New York

Collections

The Museum of Modern Art, New York
Museum of Fine Arts, Boston
Cincinnati Art Museum
Library of Congress
Honolulu Academy of Arts
Portland Art Museum
East-West Center, Honolulu
Cleveland Museum
Tochigi Prefectural Museum of Art
Tokyo University of Fine Art
Princeton University Graphic Collection